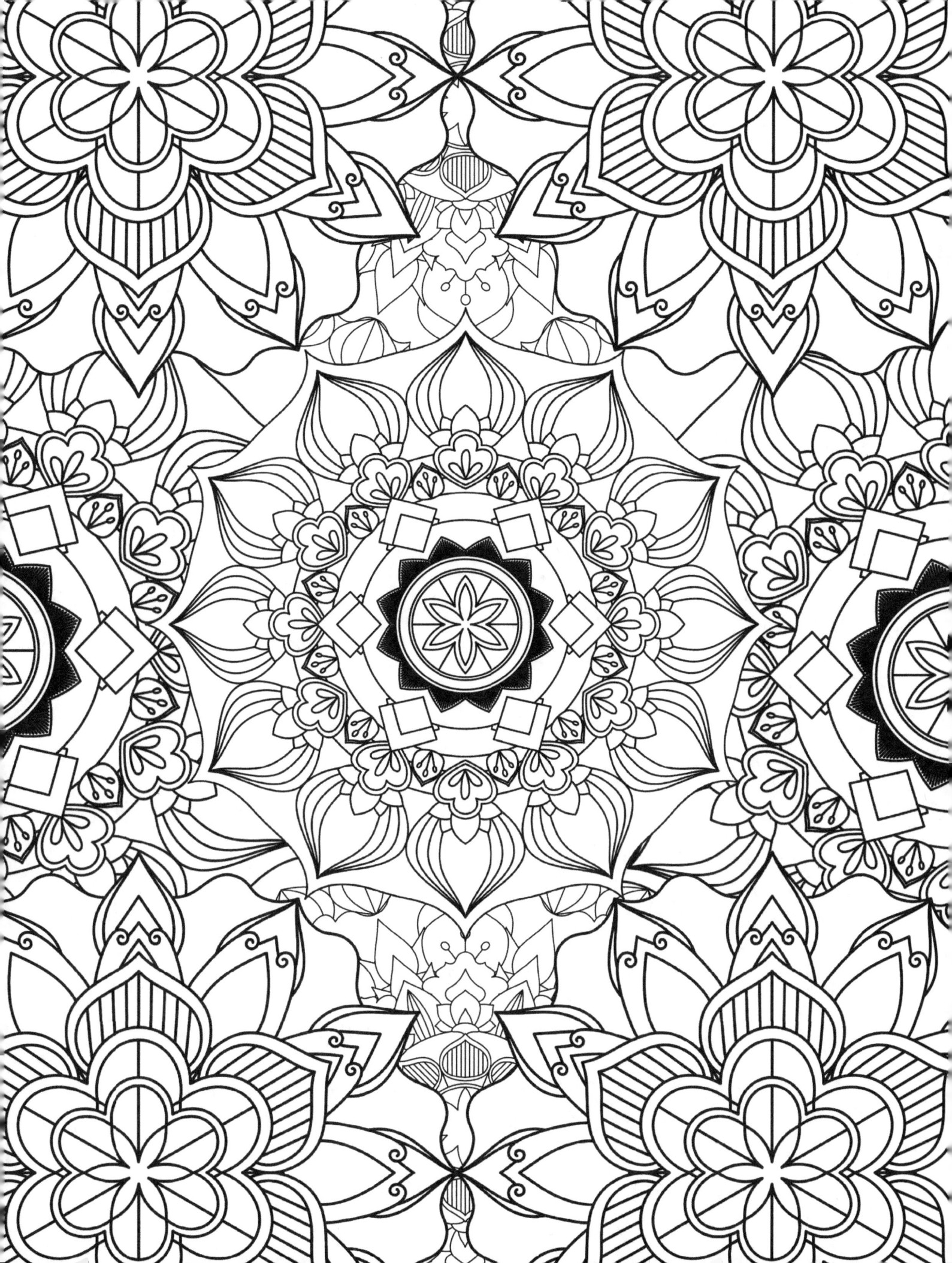

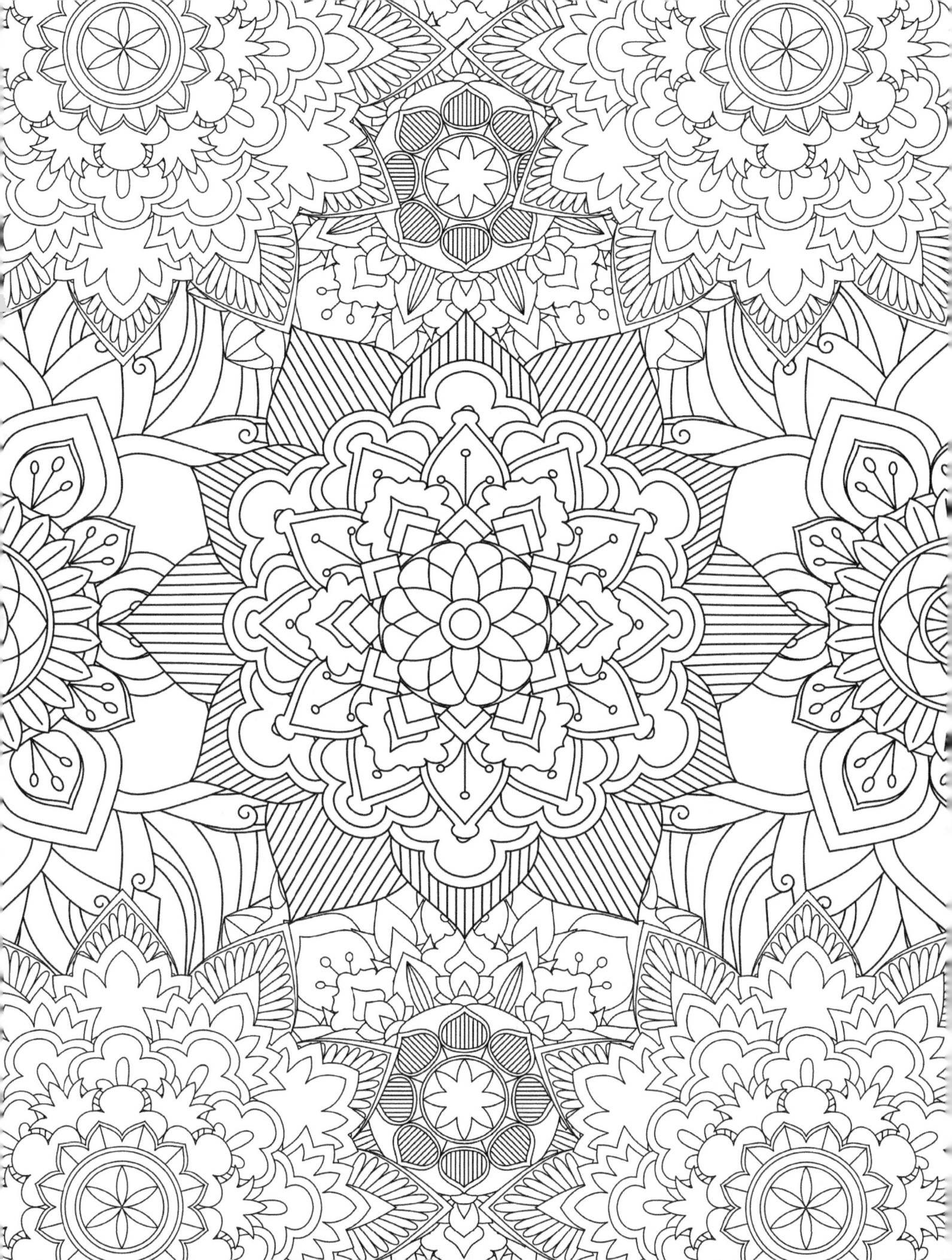

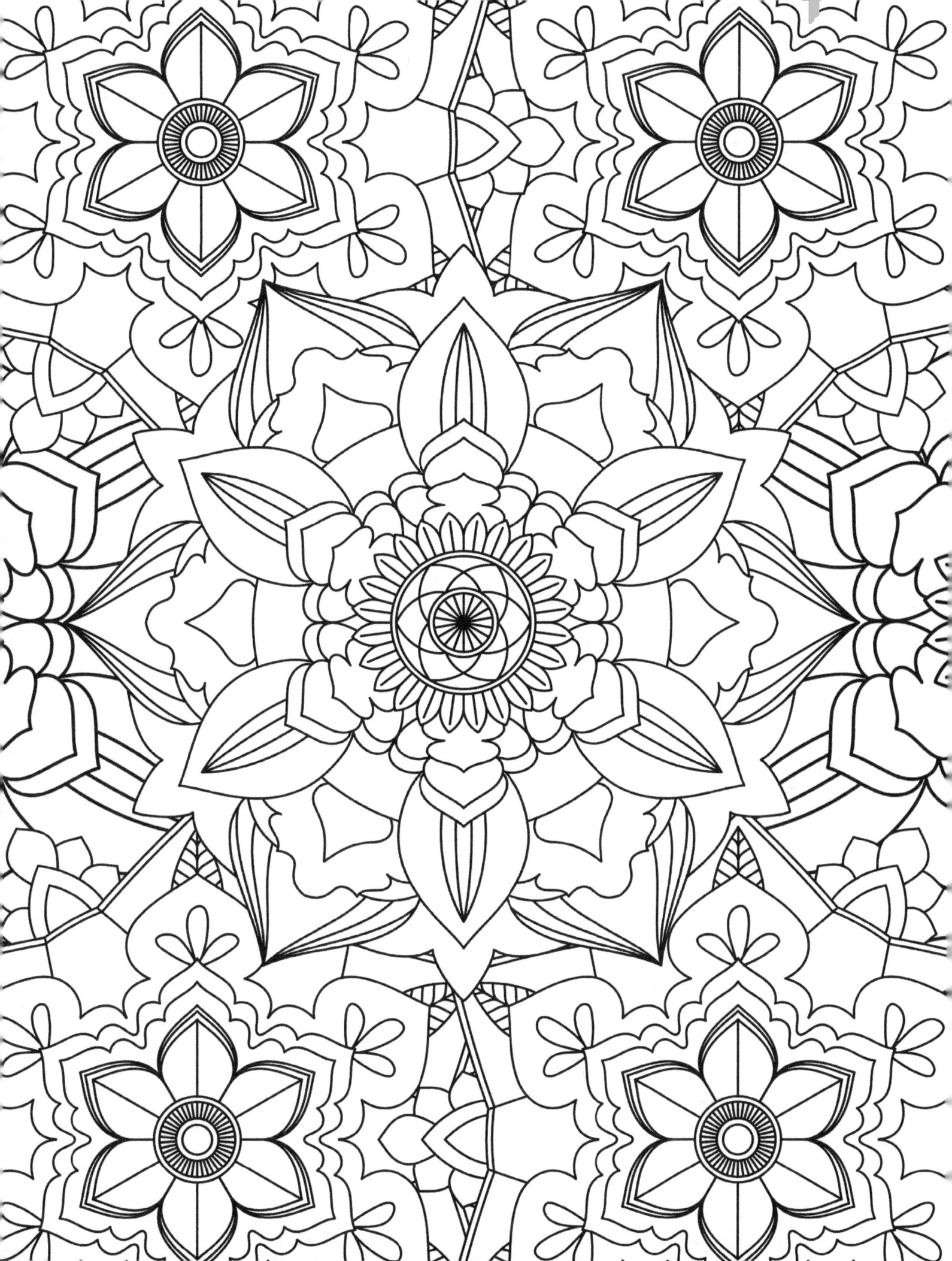

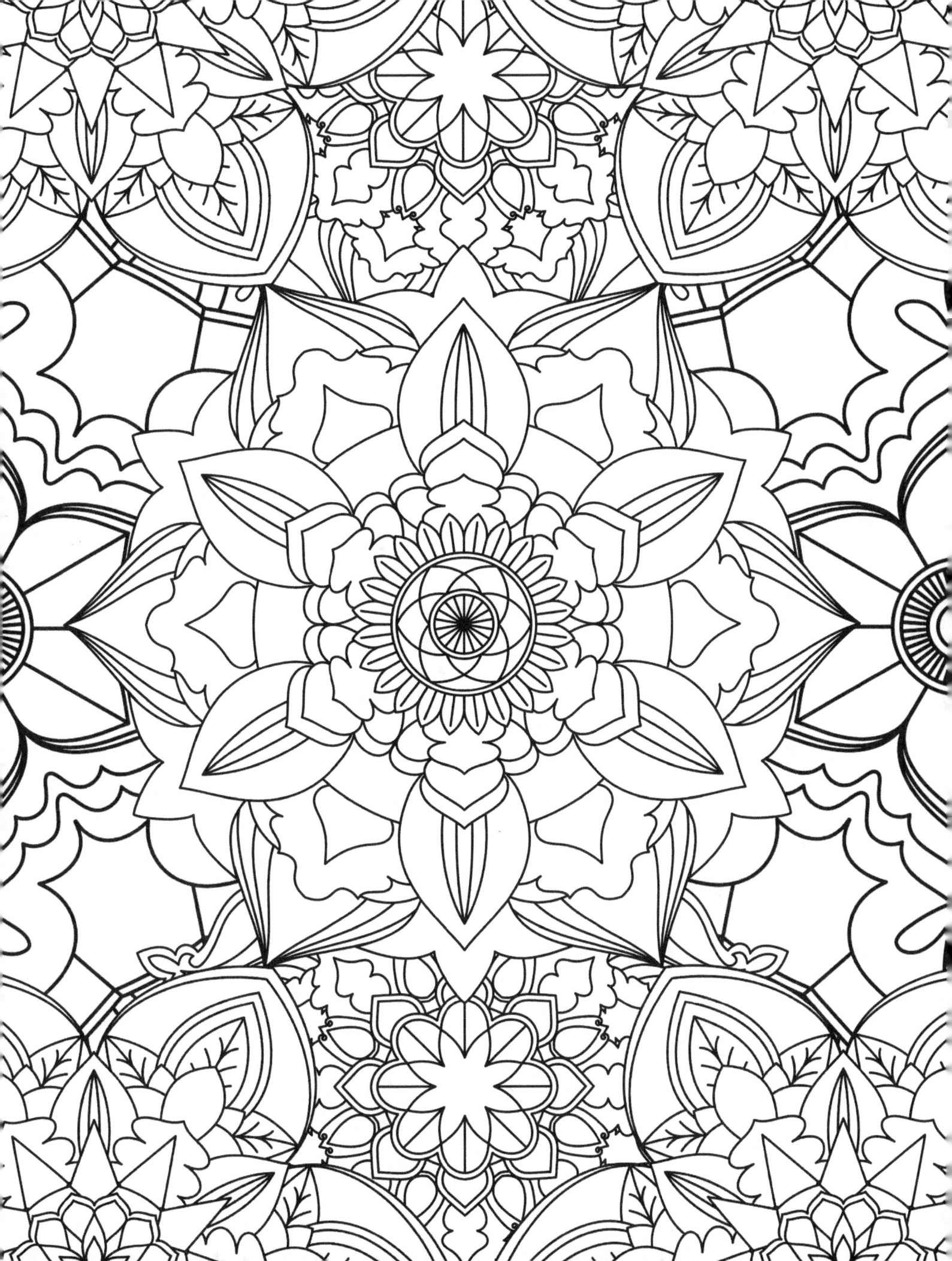

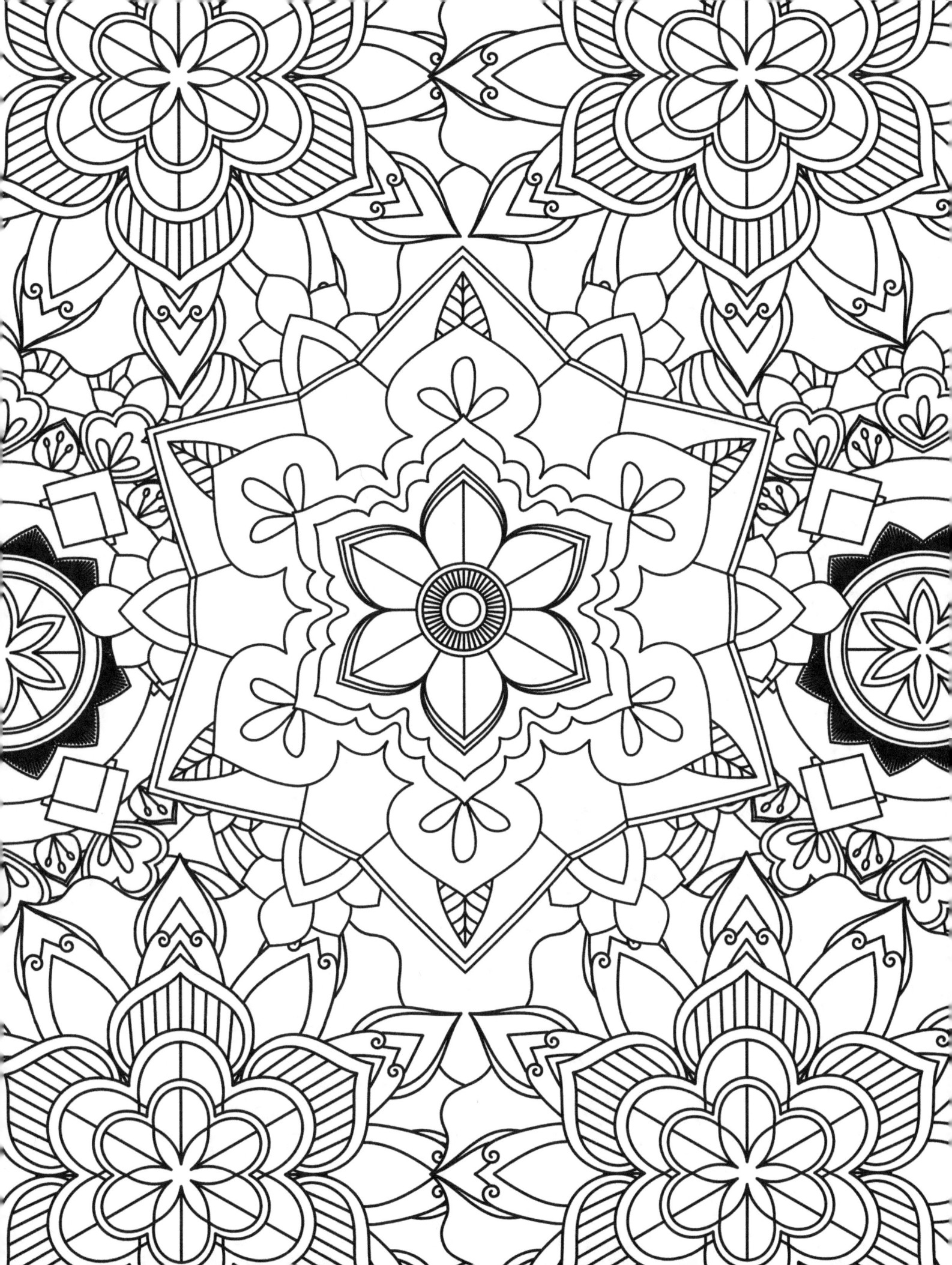

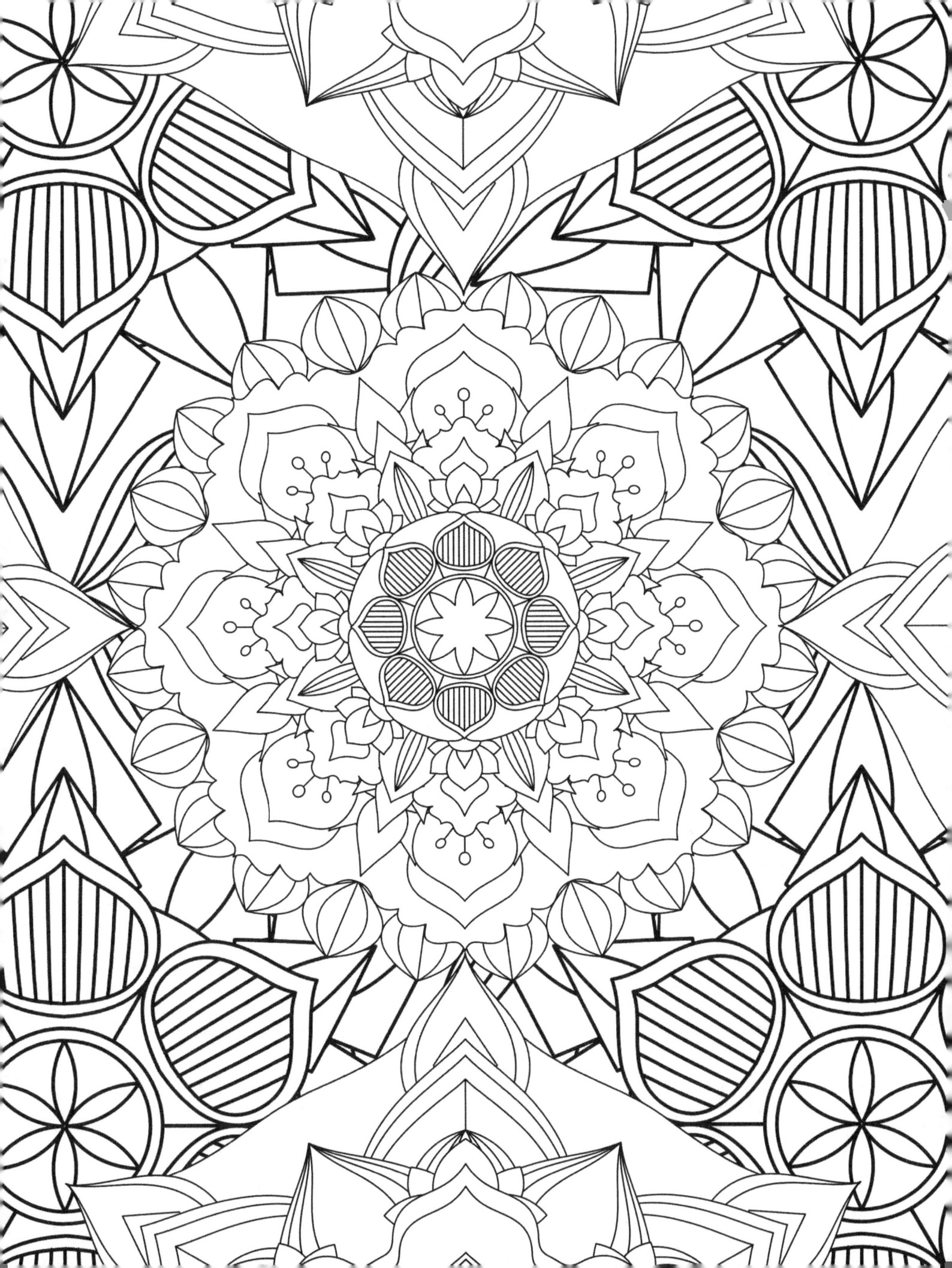

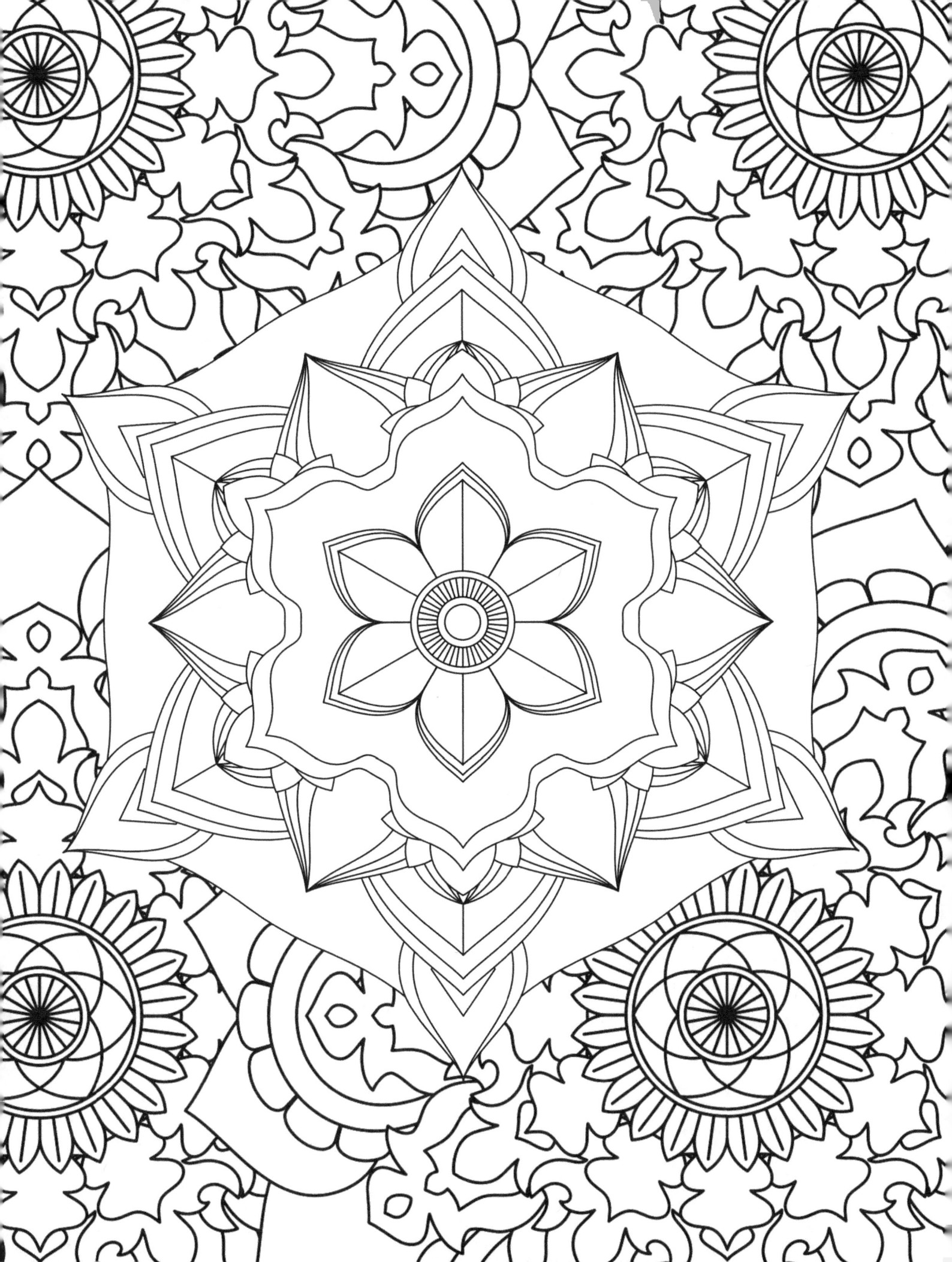

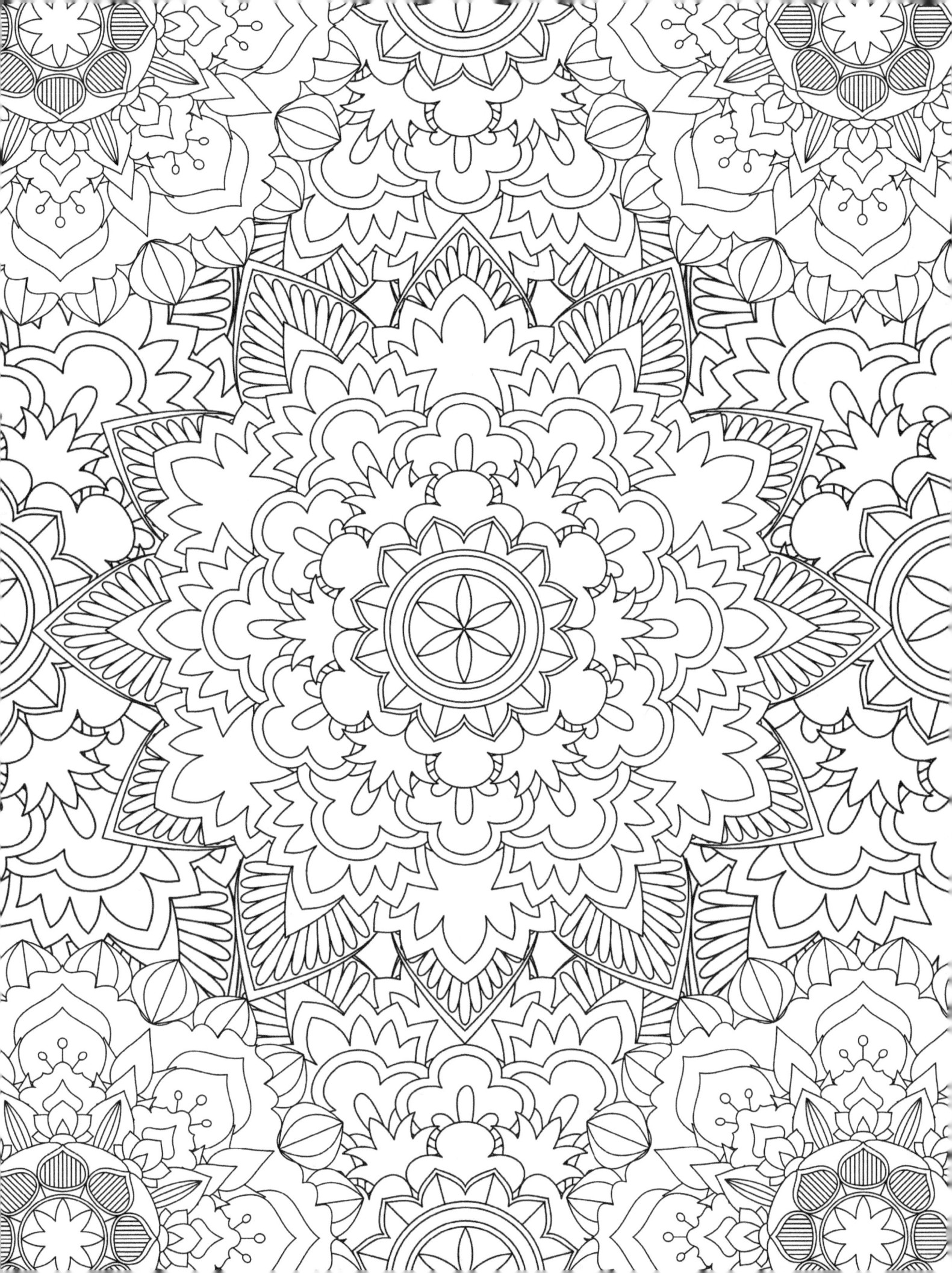

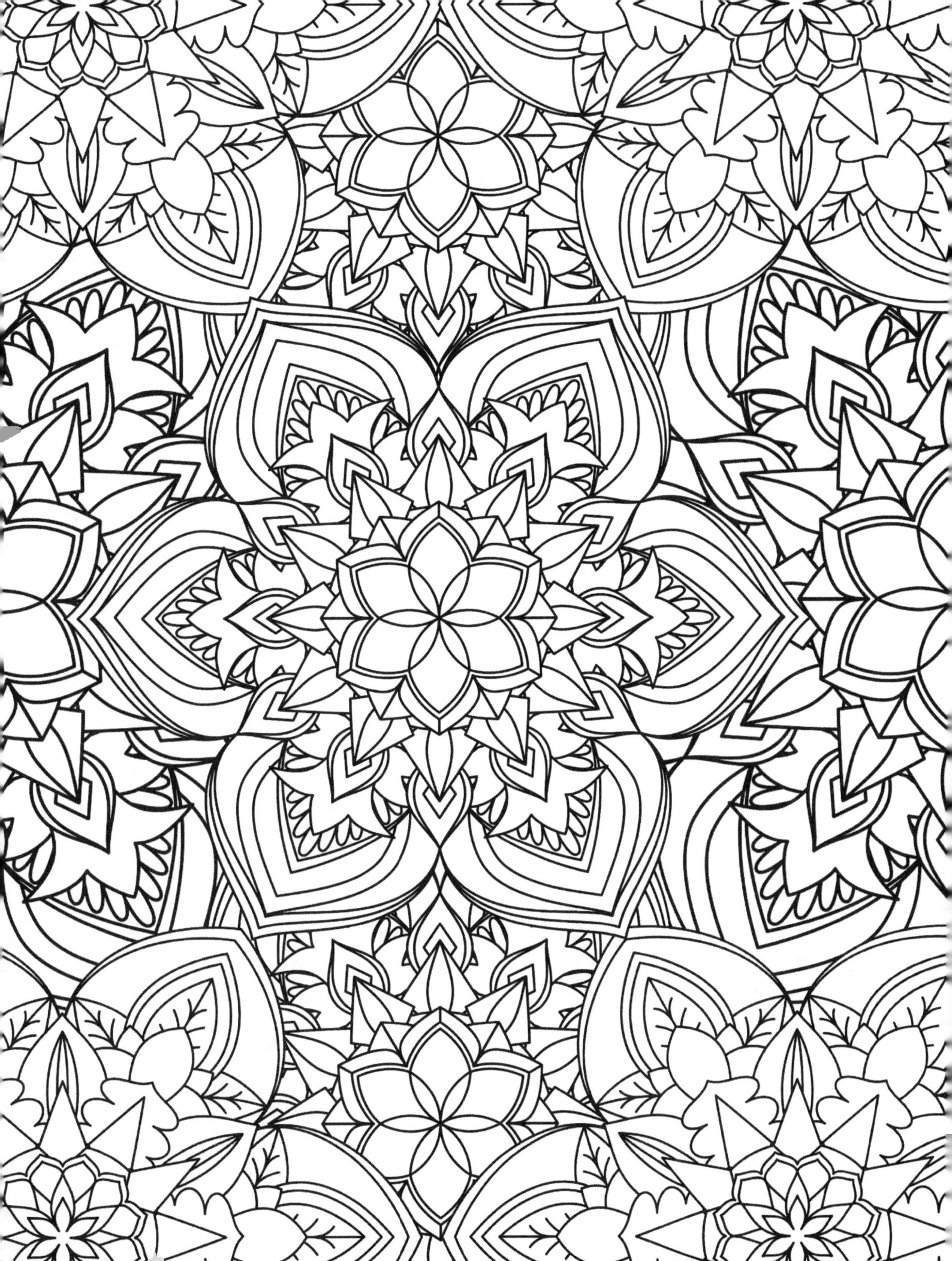

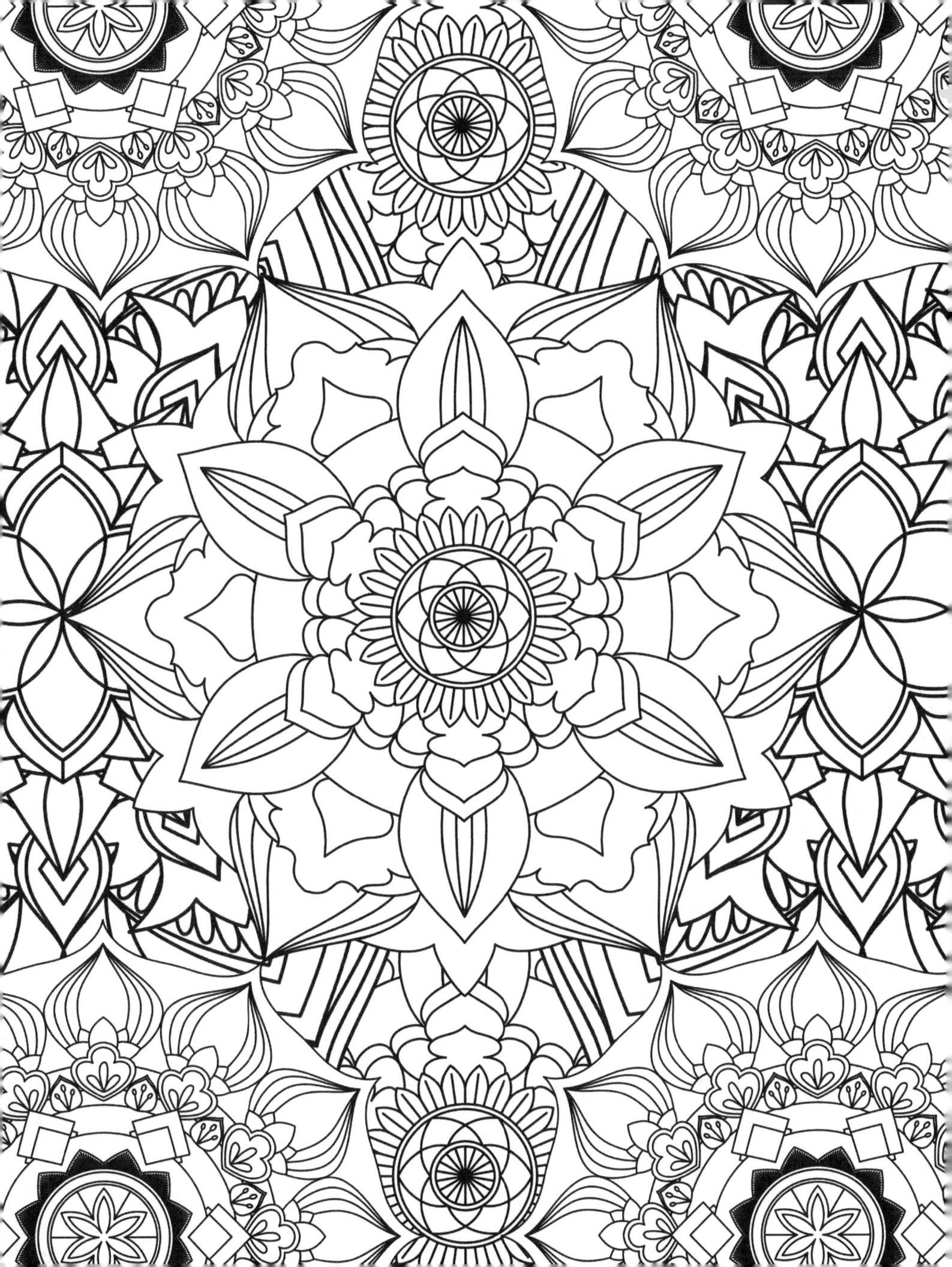

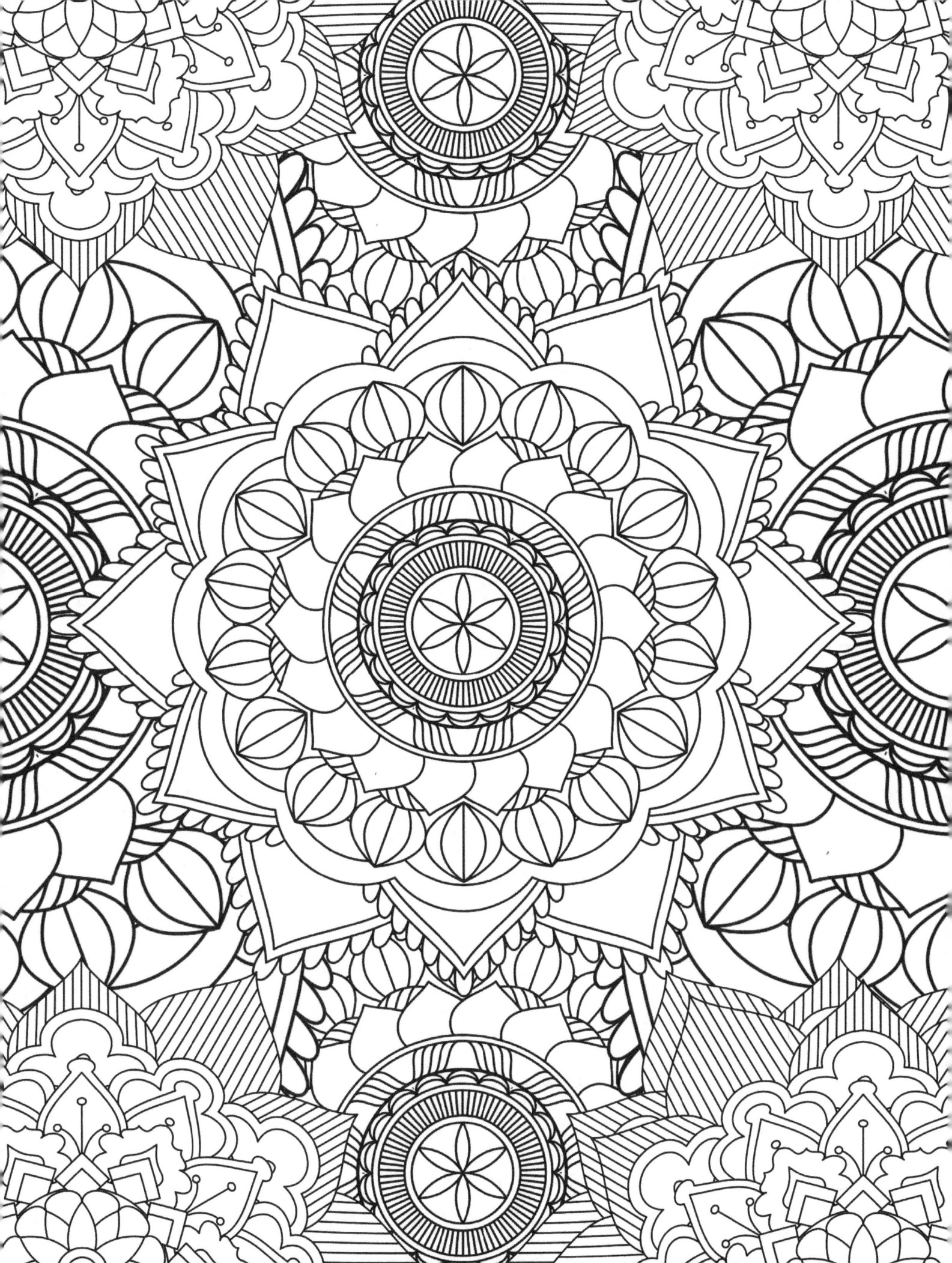

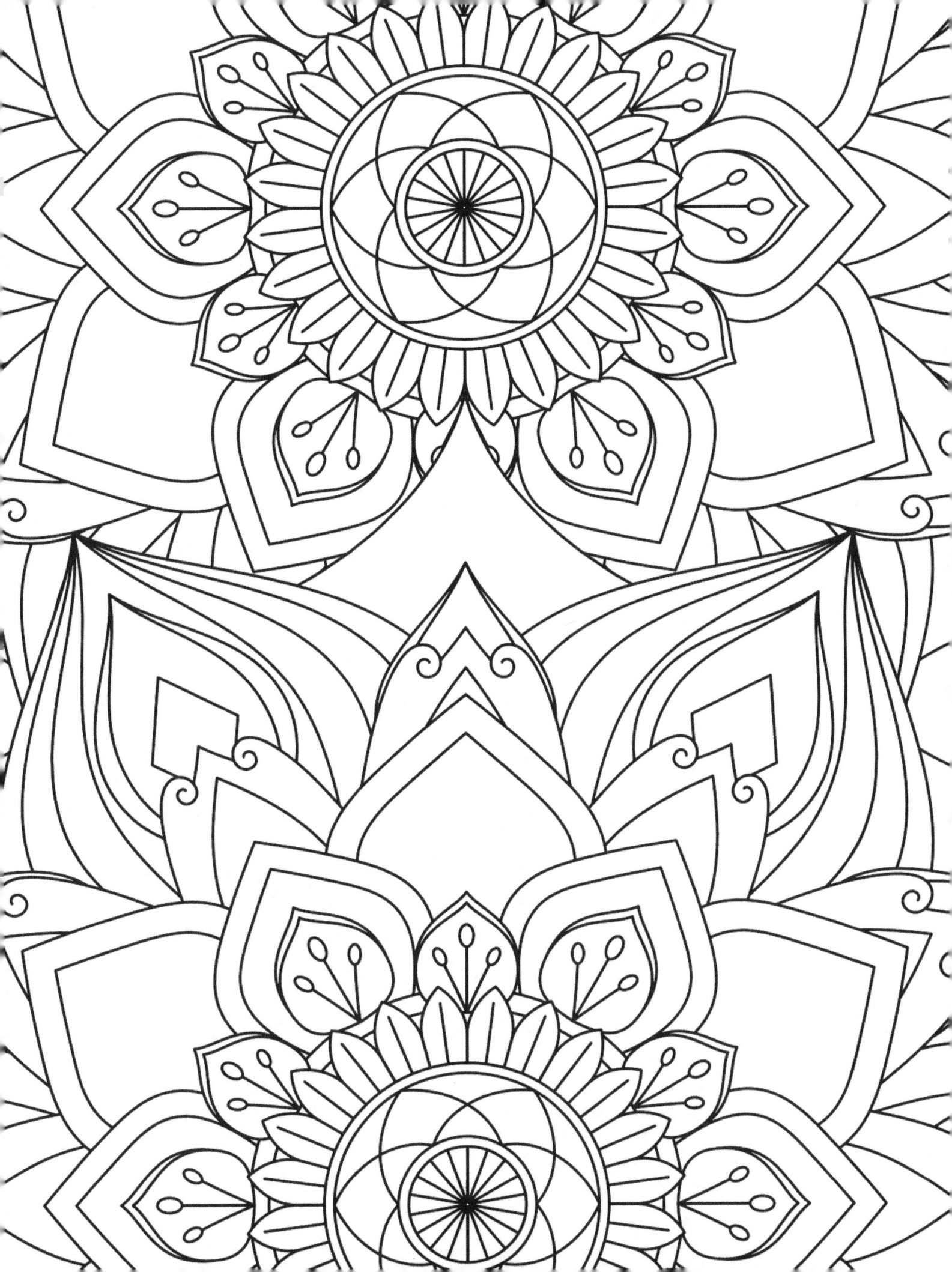

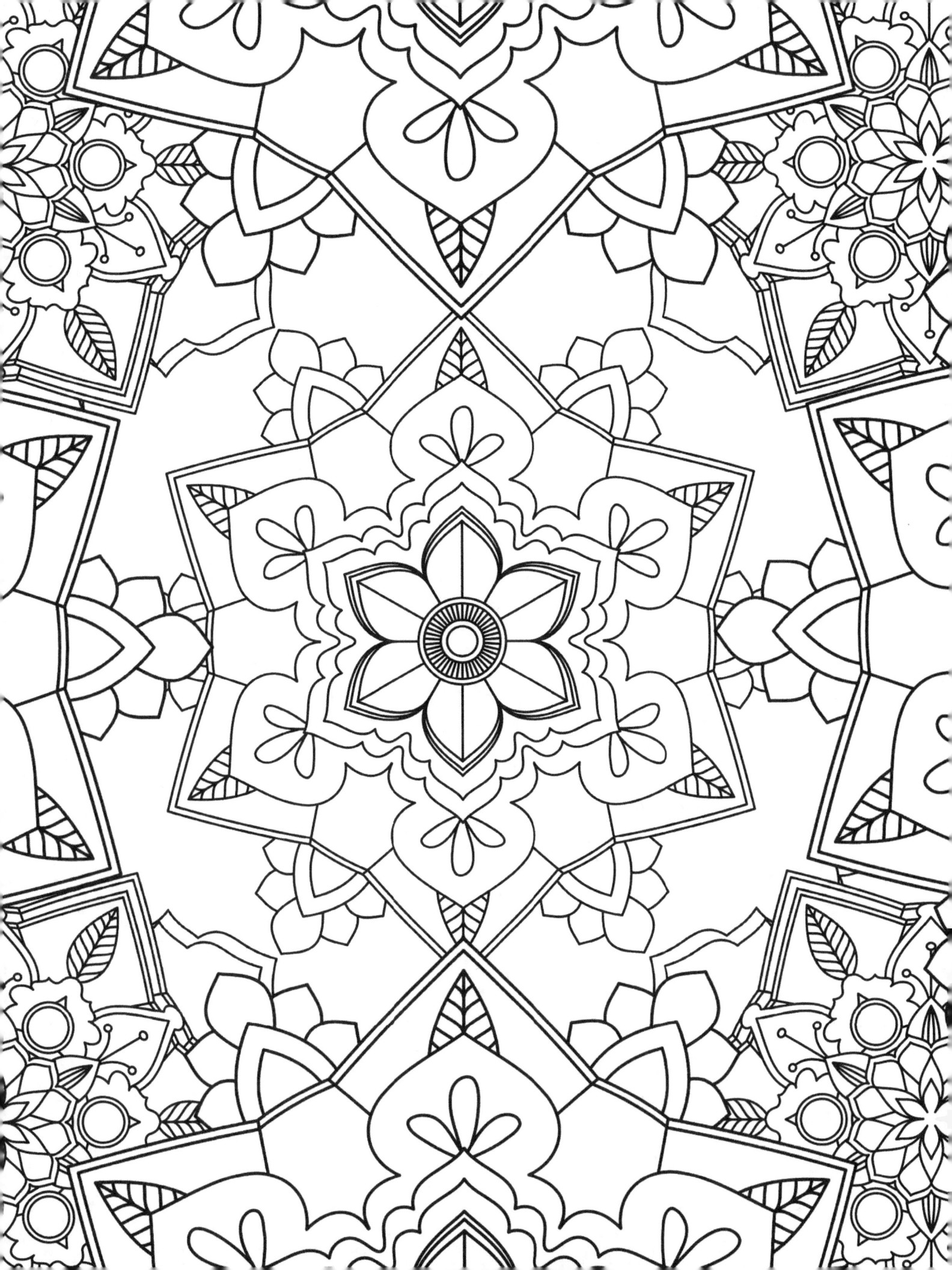

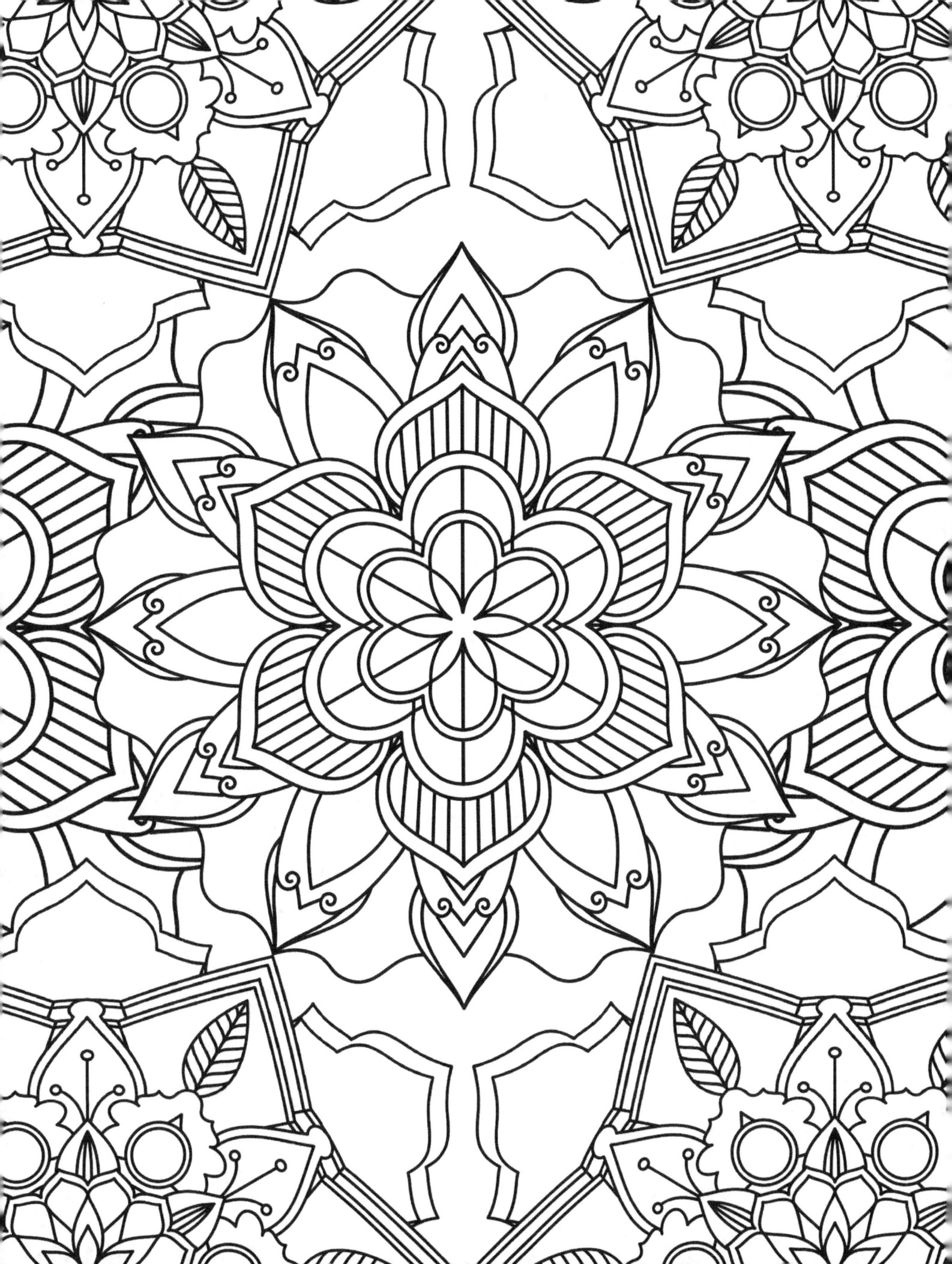

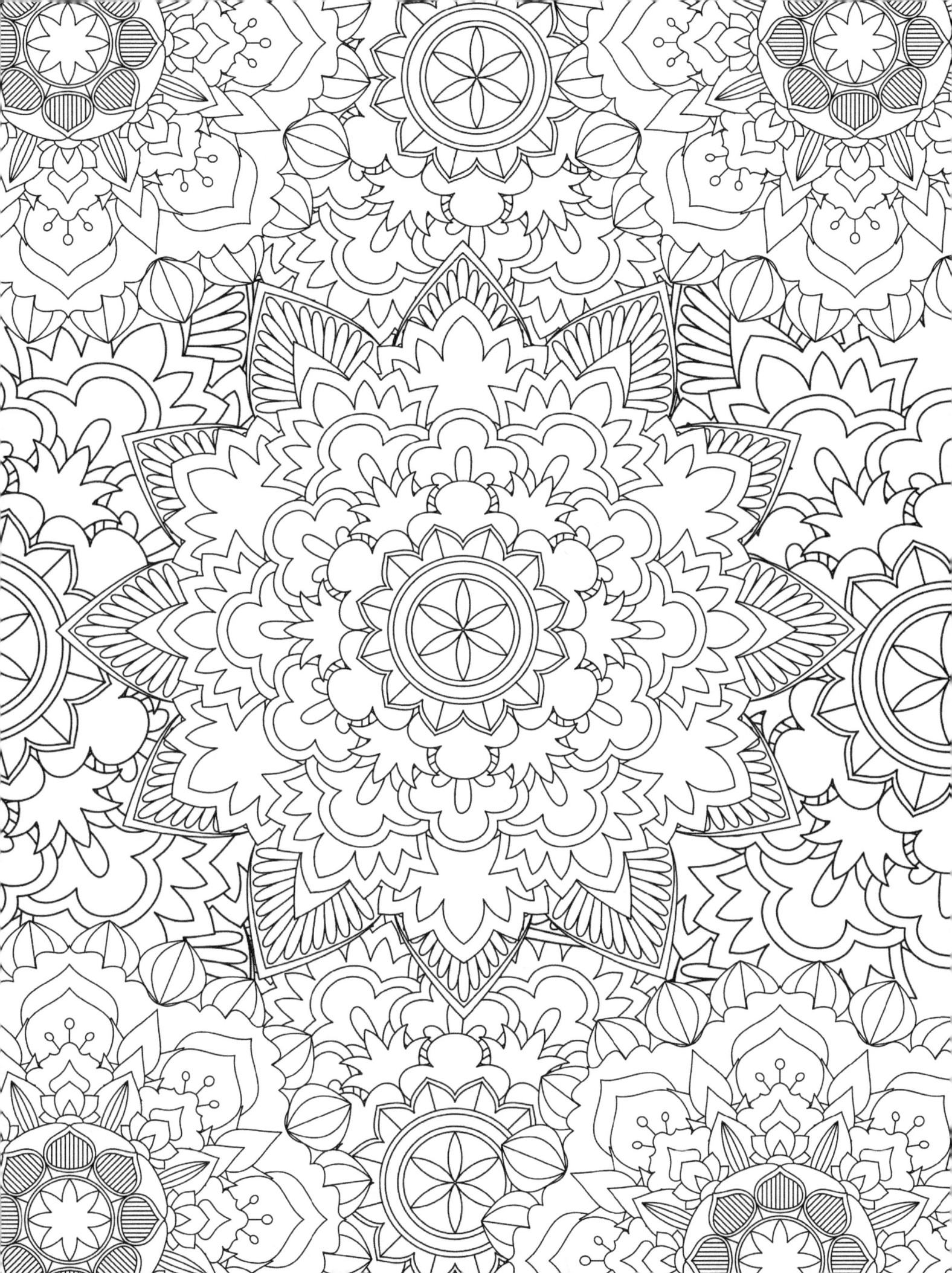

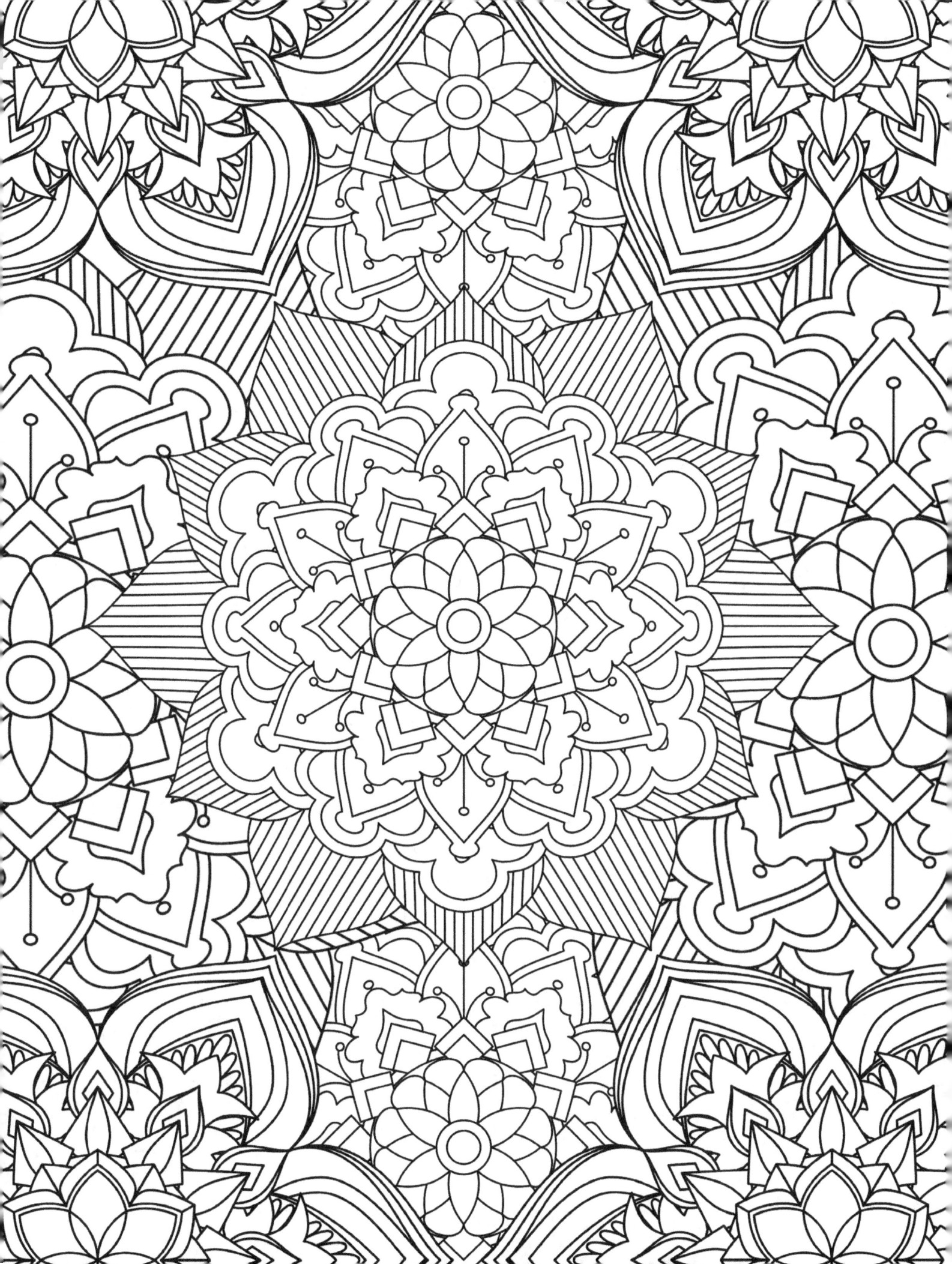

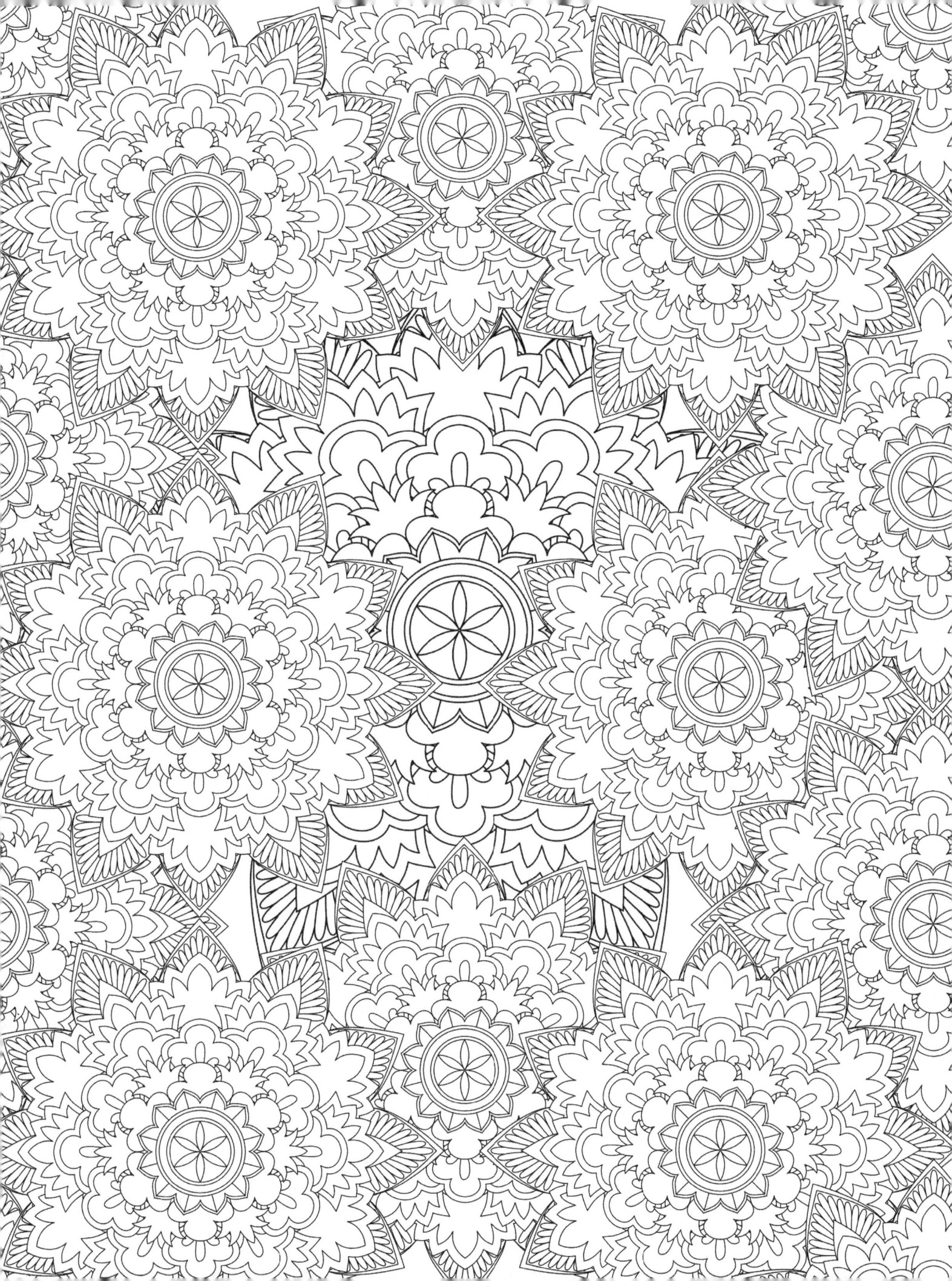

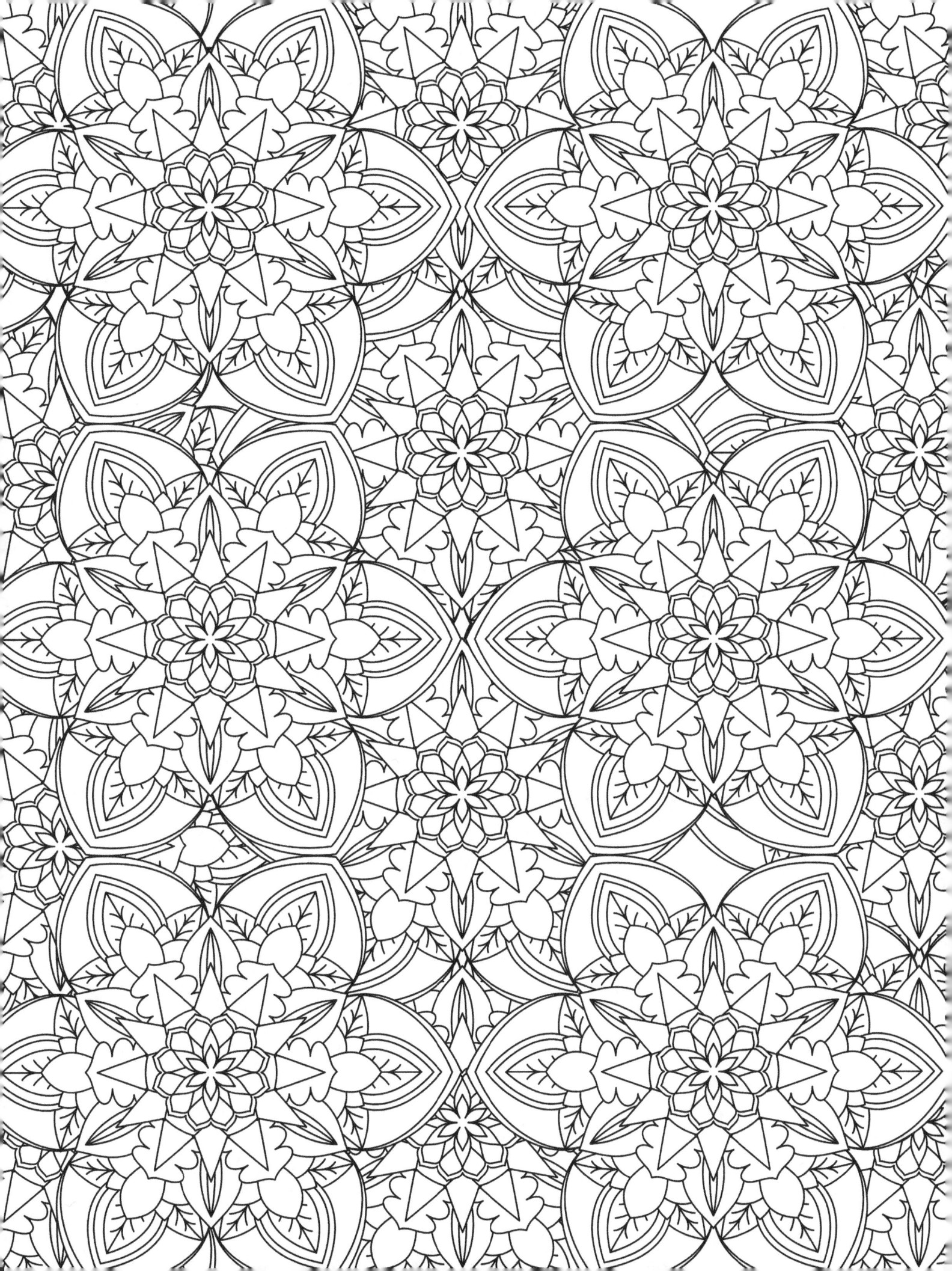

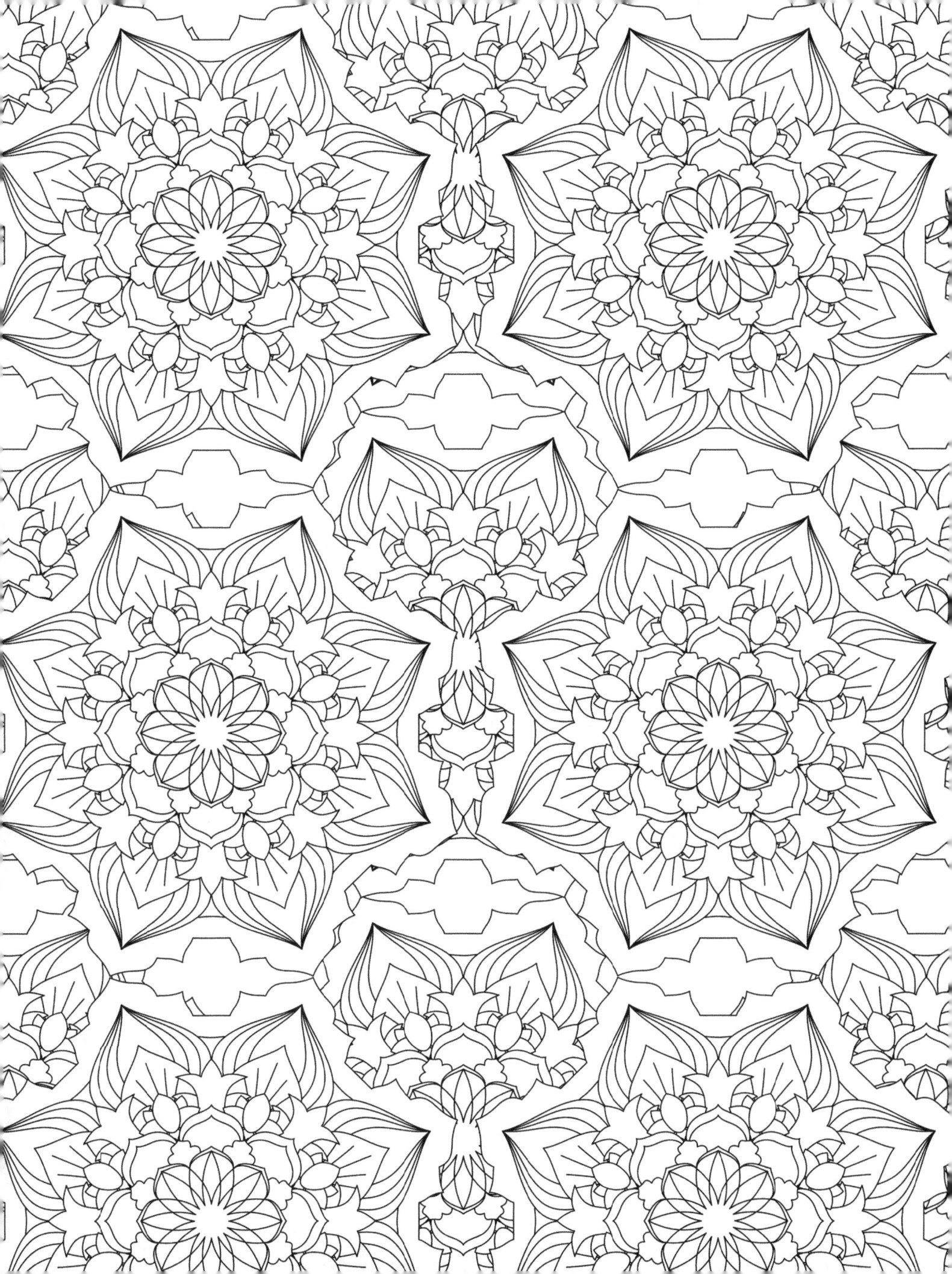

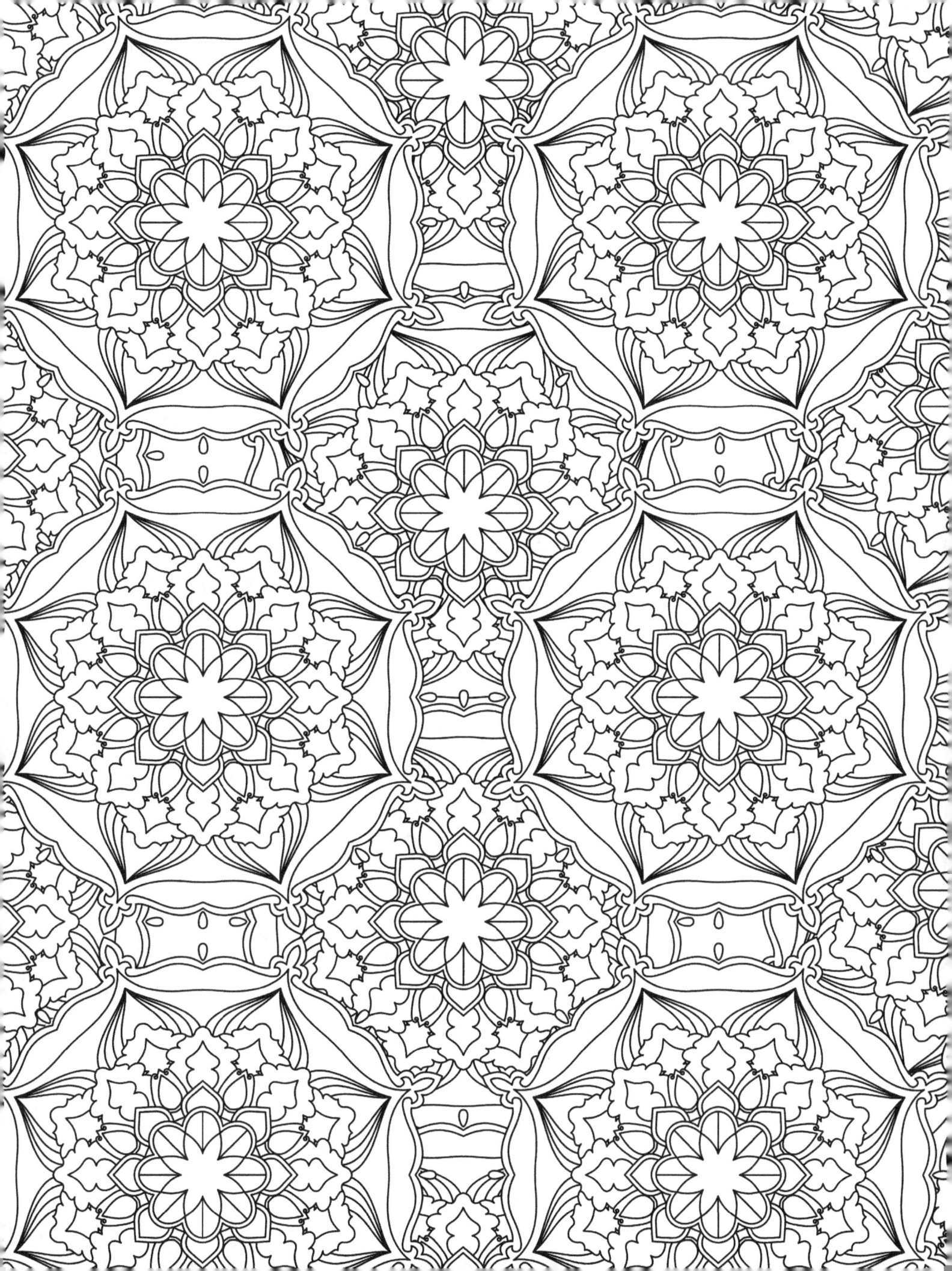